Graphic Design: Katharina Riegler
Proofreader: Katherine James
Series Editor: Matthew Koumis
Reprographics by Typoplus, Italy
Printed in Bolzano, Italy by
La Commerciale Borgogno

© Telos Art Publishing 2005
Brighton Media Centre
15 Middle Street
Brighton BN1 1AL
England
www.arttextiles.com
editorial@telos.net

ISBN 1 902015 92 4

A CIP catalogue record for this
book is available from the British
Library

Names of Photographers
Kevin Noble, James Dee

Artist's Acknowledgments
I would like to thank my long-time
assistant and friend, Man Hee Bak,
for his invaluable help and support,
and Kevin Noble, my patient photo-
grapher. Also, my sincere thanks
to Dominique Nahas for his
thoughtful and insightful essay,
and to Lois Martin for her percep-
tive monograph. For their support
of my work, I thank David Revere
McFadden, Chief Curator and
Ursula Ilse-Neuman, Curator of
the Collection, Museum of Arts &
Design. I am grateful to Lara,
David and Alex Temkin for their
wise advice. And a special thank
you to William Bartman, A.R.T.
Press, who en-couraged the devel-
opment of the fingerprint works
and gave me the opportunity to
exhibit them.

To B.H.T. in memory.

Publisher's Acknowledgments
"Extreme Scrutiny" by Lois Martin
first appeared in *Surface Design
Journal*, volume 27, Winter 2004
and is reprinted with kind permis-
sion of Editor Patricia Malarcher.
Thanks to Paul Richardson at
Oxford Brookes University,
Christopher Springham at Luther
Pendragon and Simon Stokes at
Tarlo Lyons.

Notes
All dimensions are shown height
x width x depth. Places named in
this book are in the USA unless
otherwise stated.

Pages 1 & 48:
Black Berries (detail)
2004
acrylic paint, dye, thread
30 x 30in (76 x 76cm)

portfolio collection
Merle Temkin

TELOS

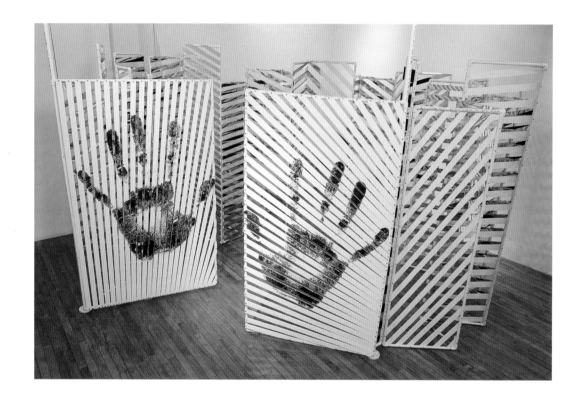

Hands-On
1986
installation
plexiglass mirror strips, plastic pipes, paint
9 x 15 x 14ft (274 x 457 x 427cm)
Sensory Evolution Gallery, New York NY

Contents

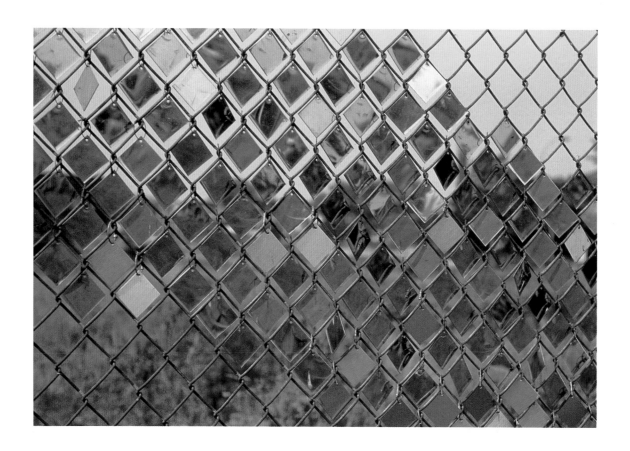

Making Waves (detail)
1991-97
installation
3000 pieces of 1 x 1in (2,5 x 2,5cm)
mirror-finish stainless steel, cable wire,
existing chain-link fence
6 x 80ft (183 x 2438cm)
Socrates Sculpture Park, New York NY

Extreme Scrutiny

by Lois Martin

Merle Temkin's paintings are intensely focused on the particular, and her scrutiny is so extreme that she forces the viewer into a perceptual leap – where scale changes, and something tiny grows huge. Her subject matter is the whorls of prints from her own skin: sometimes the ball of her foot, sometimes her thumb, and most often, her left index finger. Greatly enlarged, the ridges form spots and stripes. But Temkin's patterns are no crisp candy stripes or minimalist pinstripes. At times, they recall the bright heraldic markings of medieval pageantry. And at other times, like a camera lens zooming from extreme close-up to infinity, they alternately suggest the markings of an animal's coat or a vast view of a swirling solar system.

Paradoxically, Temkin finds that her obsessive subject matter and narrow focus lead her to ever more expansive exploration. "The work has to do with my identity...

Fingerprints... are the most personal signature... They are uniquely my own and at the same time universal."

Within her imagery, she recognizes links to her travel and experiences: in zebra stripes, French striped boat sails, mazes of city streets, and the billowing red and white of the American flag (Temkin lives near the World Trade Towers site).

Temkin's palette of black, purple and red gives off a sense of warning, as does the quality of her mark making, and her titles. There is something stirring about her marks: they have the directness and desparation of marks on cave walls. Colors cake, lines are scratched and scrabbled. A rusty or rosy understain often seeps out under dark areas. Pieces are seamed with crude sutures, and patterns stitched in rough embroidery run counterpoint to her painted patterns. Raw edges and knotted, hanging ends suggest a 'secret'

side exposed, or something turned inside out.

Temkin works on unprimed canvas that she stains, paints, stitches and then mounts on stretcher bars. Because they are stretched, Temkin's works are usually designated as 'paintings' in the art world, although their evocative impact is greatly due to her needlework.

Feminist, formal and philosophical concerns underlie her joining of thread and paint. "Years ago, the 'fine art' I saw in museums was invariably made by male artists. Women's work was domestic handiwork (like sewing) and not considered fine art." Temkin had appreciated the anonymous needlework of women around the world. As a result, she wanted to merge the categories of male and female, high and low, in her own work. At first, her stitching imitated her brushwork and color, "so the viewer would confuse it with the

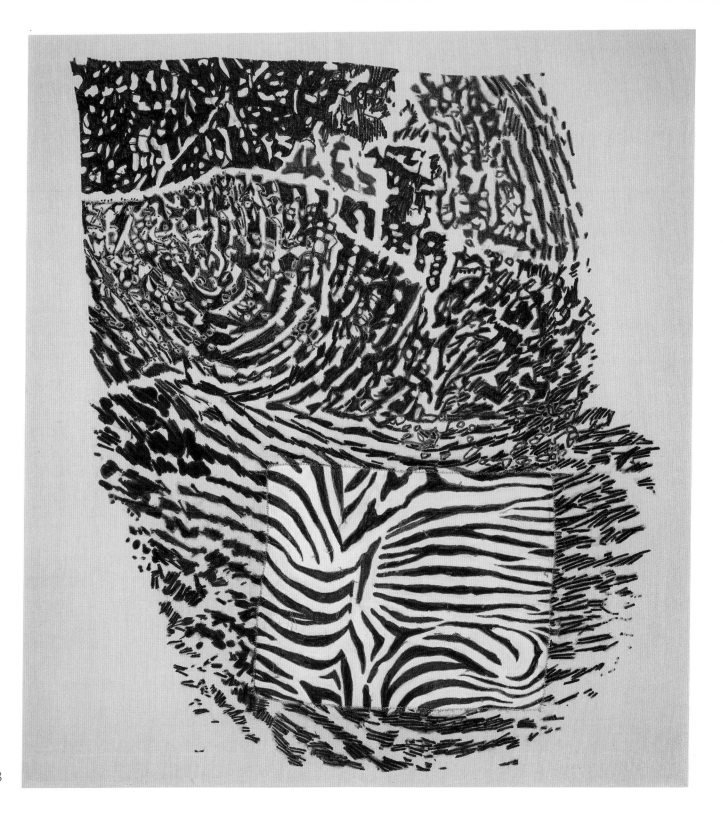

fine art of painting and accept it as such." Nowadays, Temkin is drawn to the vastly different quality of time and concentration each medium implies. While painting goes quickly, stitching is labor intensive and repetitive. It not only takes a long time, it restricts physical movement. This stillness leads to a productive state, which is a primary source for her ideas.

Temkin's earlier work, site-specific sculpture, relates in various ways to fiber techniques. In 1991, to create *Making Waves,* she stitched over 3000 small diamond-shaped mirrors into the openings in a chain link fence at Socrates Sculpture Park in Queens, New York. Temkin relates its additive, bit-by-bit construction to fiberwork methods like knitting and crochet that grow loop by patient loop.

Her focus on the hand and body also grew out of earlier installation. On a sundial sculpture constructed as part of an international exhibition in Israel in 1987, Temkin etched the image of her fingers into rocks. When the piece was accidentally destroyed, its loss prompted a move to make smaller interior pieces. In these, she concentrated on images of her hand, then only on her fingerprints.

Temkin has had numerous exhibitions both in the US and internationally. Recently, her diptych *Couple* was acquired by the Museum of Arts and Design, New York City. The diptych is a pairing of two paintings and though they are sympathetic, the two contrast in many ways. "One came quickly, the other was agony," Temkins admits. "Still, in my imagination, they are whispering to each other".

Lois Martin
is an artist and writer living in Brooklyn, New York.

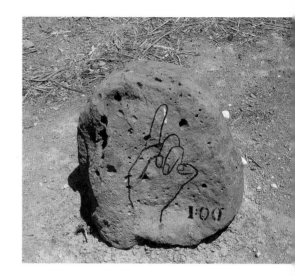

above:
Sundial (detail)
1987
permanent sculpture (destroyed)
etched rocks, concrete, paint
2 x 15 x 15ft (61 x 457 x 457cm)
Tel Hai '87, Upper Galilee, Israel

opposite:
Zebra Finger
2000
felt markers, thread,
piecework on linen
38 x 46in (96 x 117cm)

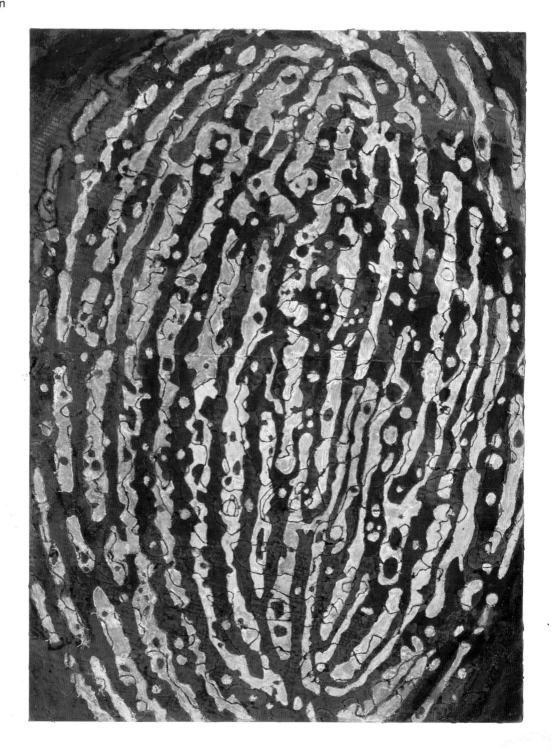

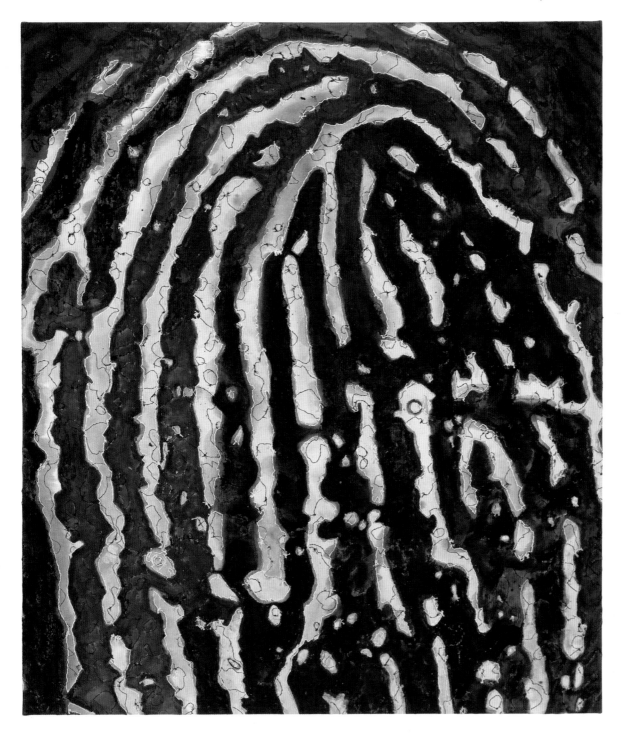

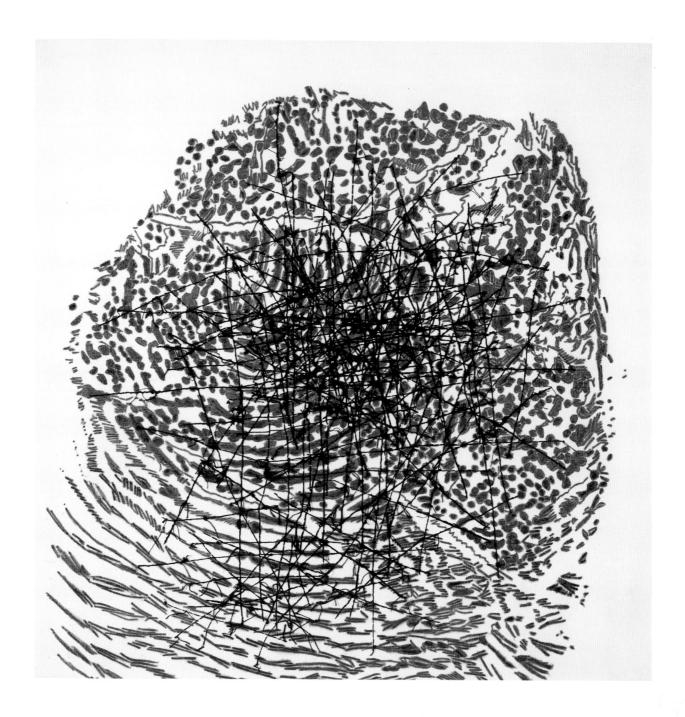

Merle Temkin: Close Encounters by Dominique Nahas

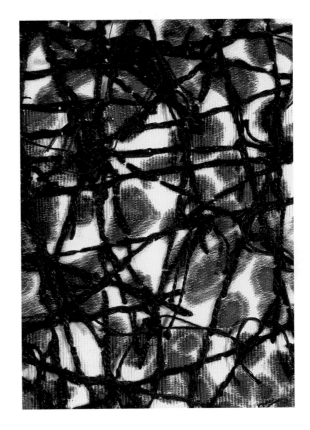

pages 10 & 11:
Couple
2001
diptych
acrylic paint, dye, thread
46 x 76in (117 x 193cm)
Collection: Museum of Arts & Design,
New York NY
The Richard Florsheim Art Fund,
Museum Purchase Award

pages 12 & 13:
Scratched
2000
felt markers, thread
48 x 48in (122 x 122cm)

Merle Temkin's signature artworks of the past several years are pictures that are as incontrovertibly authentic and singular as her very fingerprint. She has incorporated this personal insignia in her work, altering it in strikingly original ways, and has developed an unforgettable visual language in the process. Working in a hands-on way with materials such as embroidery thread, dyes, markers, and acrylic paint on paper, cotton and linen surfaces, Temkin has created an art that is suffused with vitality. Her colorful redolent energetic patterns, recalling swarm cells, weather movements, cluster formations and other emergent phenomena, are vividly tremulous to the viewer; they seem to quaver over the surfaces. Multiple sensations emerge from Temkin's complex surfaces. Her mark-making, special-organizing skills, and colored nuances extend the map of our seeing.

Using a well-honed and fluid process of working, an evident flexibility in her use of materials and an unerring trust in her improvisational skills, Temkin has over time produced an astonishingly vibrant array of paintings. The artist has had the wit and style to induce divergent readings on the beholder's part from what might at first appear to be her narrowly focused scope of study in terms of subject matter. The actual size of the works, then, seems to matter little as the scale *within* the work always defies expectation and transcends the material support structure upon which it finds itself. The artist is fond of zooming into her subject matter, then panning away from it, often in the same work, confounding our frame of reference. This macro/micro game is provocative and commands visual authority. Which is another way of saying that if each of Temkin's artworks is merely a constituent part of a bigger picture – variations on a theme – so to speak what a theme it must be and how connected she must be to it in order to make each work have such visual presence no matter how large or small it actually is. For example, compact works produced in 2004 such as *Sunset,*

Heat
2001
felt markers, acrylic paint, dye, thread
48 x 48in (122 x 122cm)

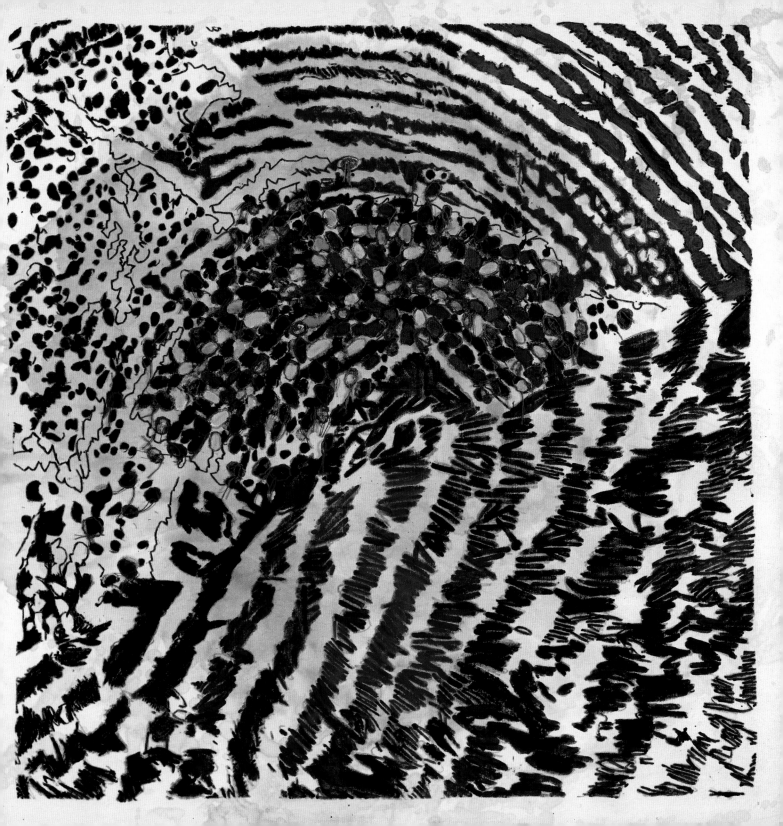

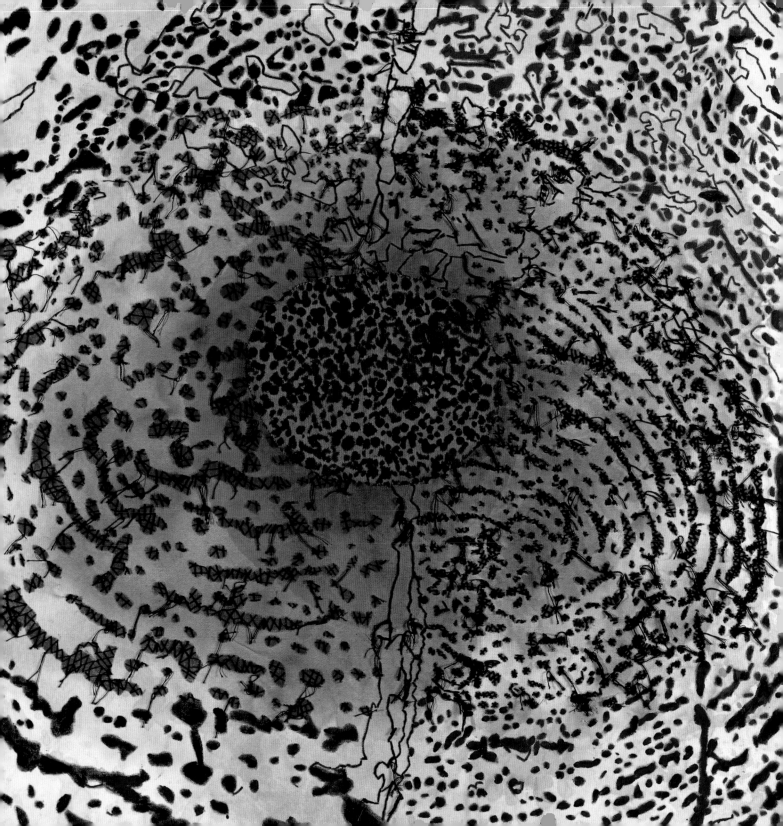

opposite:
Mayday (detail)
2001
felt markers, acrylic paint,
dye, thread,
fake fur piecework
42 x 48in (107 x 122cm)

pages 18 & 19:
Flag
2002
acrylic paint, dye, thread
40 x 42in (102 x 107cm)

Spiral, and *Cyclone* generate as much visual fire-power as earlier and larger works from 2001 such as *Heat*, *Mayday*, *Couple*, and *Flag* or the 2002 paintings *Crossfire*, *Diva*, and *Stigma*. Two of her authoritative works on canvas from 2000, *Zebra Finger* and *Scratched*, are easily matched in drama by *Only Me* (2004), the artist's current suite of small works on paper each measuring 13 x 17in, initiated during a residency at the Vermont Studio Center in 2003. The philosophical and ideational bedrock of Temkin's artistry has much to do with her poetically mundane and supramundane speculations on identifying individuality in relationship to the social sphere. Her artworks can be seen as pattern-recognition fields (based perhaps on the Rorschach model) and have therefore a relationship to projections of the imaginary psychic and physical body. Yet as they are based in some measure on real-life truths, Temkin's art is more invested in the ideational territory of mapping. For maps, as one observer has noted, "... are often borderline artworks and are always densely layered conceptional objects in their own right... As fodder for art, they are especially well suited to this post-Conceptional era, with its emphasis on politics, personal identity and systems."[1]

Temkin, through her subtly unanticipated use of paint, dyes, threads, fabrics and paper, creates systematic and rigorous work. It relates to the issue of the biologic self, and the constructed self, as well as with concerns of security in terms of identification, mis-identification, and of inscribed identity and displaced, shifting and multiple identities. The artist's painted and stitched work additionally brings out contemporary discussions which center on the role and place of hand labor and craft and their ever-shifting relationships to the finearts seen through the lens of modernism and its post-modern articulations.

Adjoining these conversations are those issues which are by no means tangential to her primary considerations of identification: vitalism, femininity, scarification, pattern

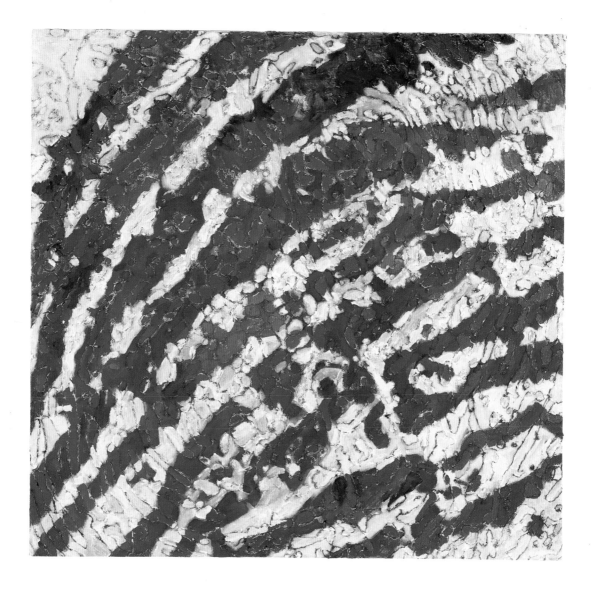

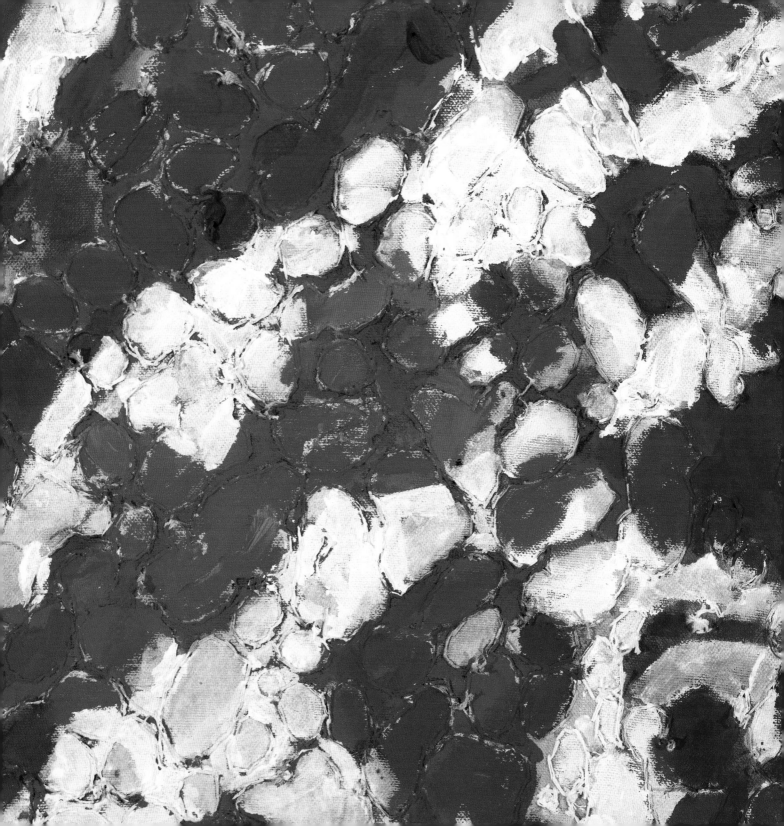

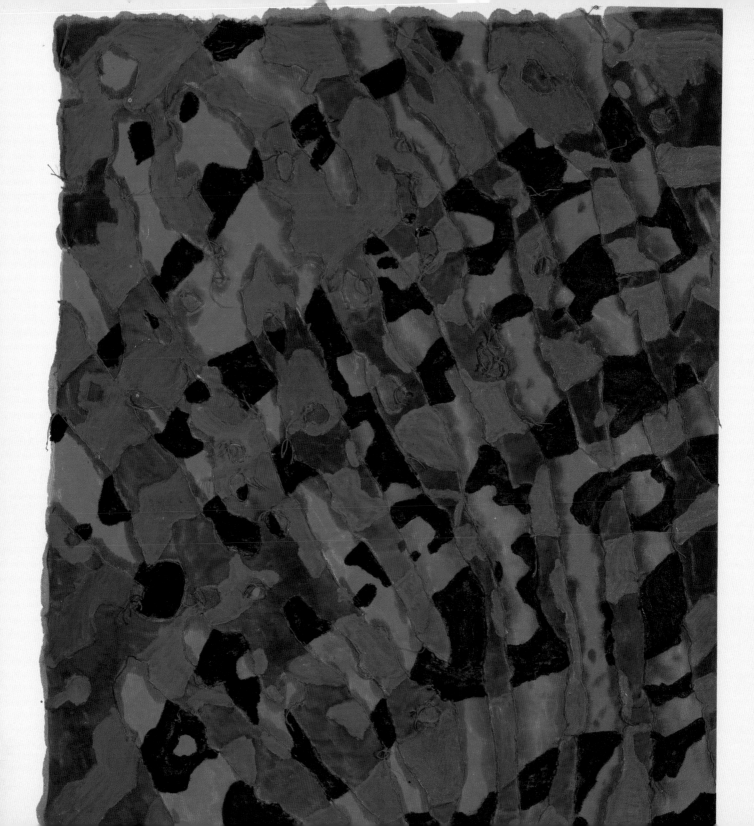

and decoration, fetishism, origina-
lity, singularity and cartography [2]...
each of these jostle for primary
consideration as the eye and mind
scan the artist's surfaces. Those
are so structured as to appear con-
fidently disheveled yet carefully
synchronized, at once fierce and
delicate, brusque and discordant,
frenetically animated yet precisely
orchestrated. In viewing her work
we experience overall patterns
which are all at once harmonious
and feverish.

This near-emblematic image of the
fingerprint (Temkin favors her left
index finger to do the heavy lifting
in terms of public appearances)
is one which has preoccupied her
for more than a decade. The finger-
print as the identifying icon of
individuality, forensic authority,
of singularity and difference as well
of commonality and community
finds its way in each of her works.
She has made it clear that focusing
exclusively on the paradigmatic
fingerprint's swirls, loops, whorls,
arches and tiny ridges has allowed
her a wide amount of freedom:

"The more narrow I get the more
freedom I get and the more creative
I become," she remarked recently. [3]
Significantly she has also said:
"The work does have to do with
my identity and erasing it." [4] The
tug between the poles of objectifi-
cation and subjectivity of the self,
between self-expression and its
annihilation remains a constituent
element of the freedom to which
Temkin refers. Structured improvi-
sation seems to be the operative
methodology which allows a fair
amount of tantalizing ambiguity
to accumulate in the work.

One of Temkin's working devices
which sets off the multiple readings
in her work is to arrange a set visual
pattern language in space and pit it
against another seemingly similar
yet vaguely antithetical pattern
structure drawn from the same
blueprint. The idea is to use the
same pattern from the same finger
but favor one area of the print to
form a work and focus on another
quadrant of the same print to offer
a counter-claim of authenticity.
This incongruous conflating of

Crossfire
2002
acrylic paint, dye, thread
34 x 40in (86 x 102cm)

visual dialects from one region of the body produces resonant irregularities that are most impressive.

Overlapping, redundancies and mis-strikes produced by design add a note of febrile awkwardness, of rawness to the work. A good example is *Do Us Part,* a 2003 diptych in which the artist uses a paper stencil to demarcate on her unsized canvas surfaces two greatly magnified yet different quadrants of the same finger's markings. Similarity of a certain type is stressed as well as deviancy and variation within a known quantity. This doubled work, presented as pendants (portraits of a couple) contains two mutually exclusive yet strangely congruous segments … as if incompatible partners have been conjoined in an incongruously appropriate way. Temkin explains it this way: "It's like a marriage in which two people fit together in some ways, while in other ways don't fit together at all."[5]

The colors, in typical Temkin-style, are evocatively sumptuous.

The use of maroons and purples appear oddly matched yet mismatched in the underlying dye which serves as a support field. The off-register aspect creates deliriously buoyant effects which heighten the elegiac use of symbolic purpling. The artist recounts that they remind her of the color which is used in Roman Catholic liturgy to recall death and mourning, and that rare purple pigment was originally extracted from mollusks in ancient Tyre, Lebanon for use in garments of the highest ranking Jews. In *Do Us Part* such mindful color play heralds life as well as its ebbing.

The more one looks at her work the more impressed one becomes with Merle Temkin's capacity to incorporate an overall sense of combinatory aliveness in her work. In *Yes* (2003) the artist uses a paper stencil to set off a field of patterning, to bring out the fingerprint whorls. Here again a careful orchestration of parts to wholes is applied: Temkin uses two parts of a canvas which are then sutured

Diva
2002
acrylic paint, dye, thread
36 x 42in (91 x 107cm)

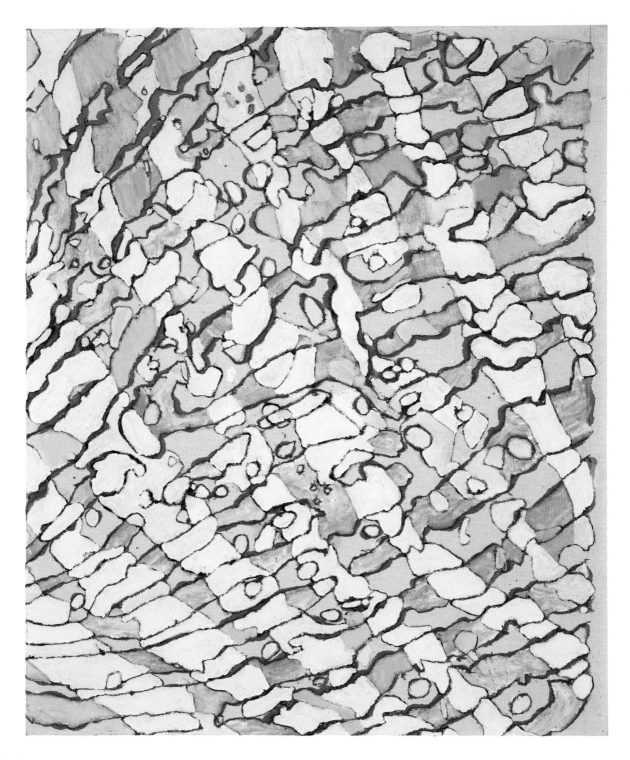

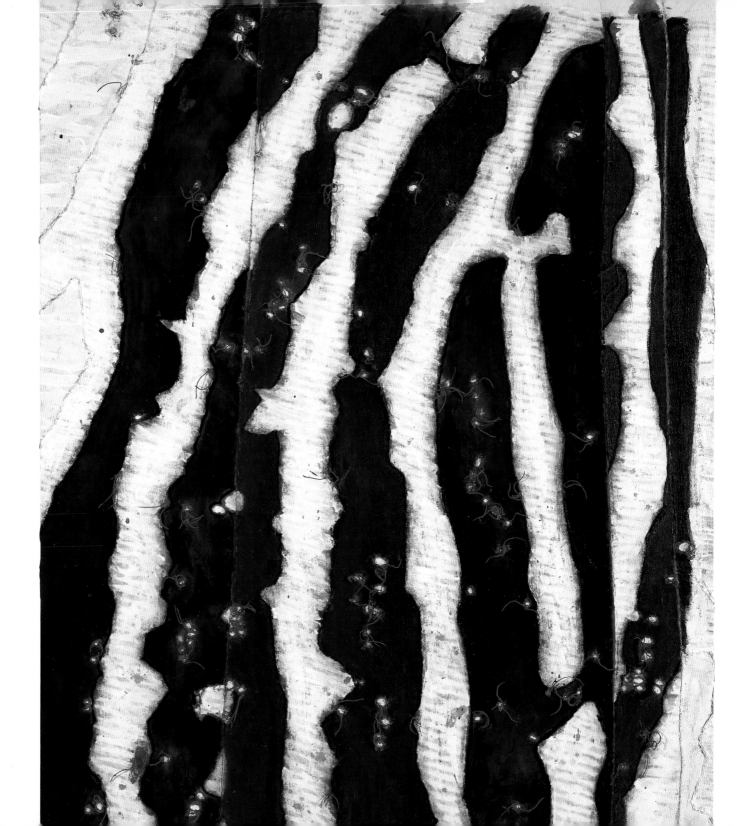

Stigma
2002
acrylic paint, dye, thread,
piecework
30 x 36in (76 x 91cm)

together; two seemingly incompatible sections are morphed together in a jubilantly turbulent entity.

Berries and *Candy Man* (both 2003) are good examples of how uninhibited Temkin is as she extrapolates from the template contours she originally draws on the canvas. Reiterated forms, colors and textures create the sensation that we might possibly be looking at the loops and swirls of a fingerprint under two vastly different magnifications. Temkin's tolerance of (even insistence on) a measure of slippage and chance to counterbalance the pre-determined aspects in the pieces creates powerfully expressive works. In *Berries* it is hard to pick out from afar if there is any coherent pattern at play at all. Only by observing the pictorial surface from a short distance and then seeing it from afar do we see how Temkin manages to balance a variety of optical qualities, textural elements and feeling sensations (dry and wet/loose and tight) to create an overall impression of spontaneity and freshness.

The fingerprint is inevitably associated, symbolically speaking, with the work of the hand (with soma) and with the body's relation to the mind. In the context of the arts it is hard not to associate the hand/ fingerprint signifier with controversial aesthetic discussions regarding subjectivity and the values of uniqueness as a sign of authenticity in art production.[6] Temkin threads disparate conversations within her work: the subject of her densely painted and embroidered paintings may be the fingerprint, while the content of the work is something entirely Other.

The artist has developed a body of work which not only relates to the issue of the self, but also informs the issues of identification, mis-identification, and de-identification as well as their displacement aspects. Her stitched notations bring out contemporary discussions centering on the role and place of the hand [7] seen through the lens of modernism and its post-modern articulations. Added to these conversations are her

concerns touching upon sensation and intensities, mimicry, fetishism, singularity... each of these jostle for primary consideration as the eye and mind scan Temkin's colorful and complex surfaces.

Merle Temkin has used the repetitive fingerprint motif in her work successively over the years, doing so in nearly counter-intuitive ways. She has emblematized the schematic signs of uniqueness in all of its permutations and irregularities by creating a process and working style which is equally and irrepressibly differentiated. The artist suits her expressive needs and intellectual curiosity by consistently experimenting with unconventional processes aimed at exploiting the print's iconic structural format. In doing so Temkin's labor-intensive cartography sutures the map of autobiography onto that of the universal in sharply revelatory ways.

Essay by **Dominique Nahas**
Writer, independent curator, contributor to *Art in America, Art Asia Pacific, Sculpture*, Faculty member of Pratt Institute and Maryland Institute College of Art.

NOTES
[1] Roberta Smith, "Mapping," *Art in Review. The New York Times,* October 14, 1994
[2] Maps give men and women the power of gods and captains, but their attraction to artists is somewhat different. For though a painter or sculptor may also enjoy that feeling of universal mastery, the particular opportunities maps provide visual artists – and their special appeal to modern sensibilities – result from their being the ultimate pictorial coincidence of exacting representation and total abstraction. Robert Storr, *Mapping*. New York, Museum of Modern Art, 1994, p.13.
[3] Conversation with the artist, October 15, 2004.
[4] Judith Page, "Merle Temkin and Judith Page; A Conversation in Merle's Tribeca Studio, May 2000," *Merle Temkin – Personal Markings*, New York, *A.R.T. Press*, exhibition catalogue, unpaginated.
[5] Conversation with the artist, October 15, 2004.
[6] A gamut of positions cn be mapped

in the modernist concern with the role of the artist as a 'producing subject'. Starting with an unquestioned insistence on the artist as genius, original, inspired and unique, they expand to include the idea of artist as fabricator, as initiator of an idea rather than producer of work. Ultimately the critique of the artist leads to a critique of originality, transcendent genius and mastery which has been central to the romantic model. Johann Drucker, *Theorizing Modernism*. New York, Columbia University Press, p. 110.
[7] Temkin's art involves repetitive handiwork. It joins the lively conversatino of artists whose works interweave and contaminate traditional morphological, class and gender classifications in their work. Here are a few names from a growing list: Ghada Amer, Alghiero e Boetti, Oliver Herring, Nene Humphrey, Rosa Lee, Leonilson, Darrel Morris, Nicolas Moufarrege, Elaine Reichek, Steven Sollins, Charles Spurrier, Kate Talbot, Anne Wilson.

Pink
2003
dye, thread, pieced cotton
38 x 44in (96 x 112cm)

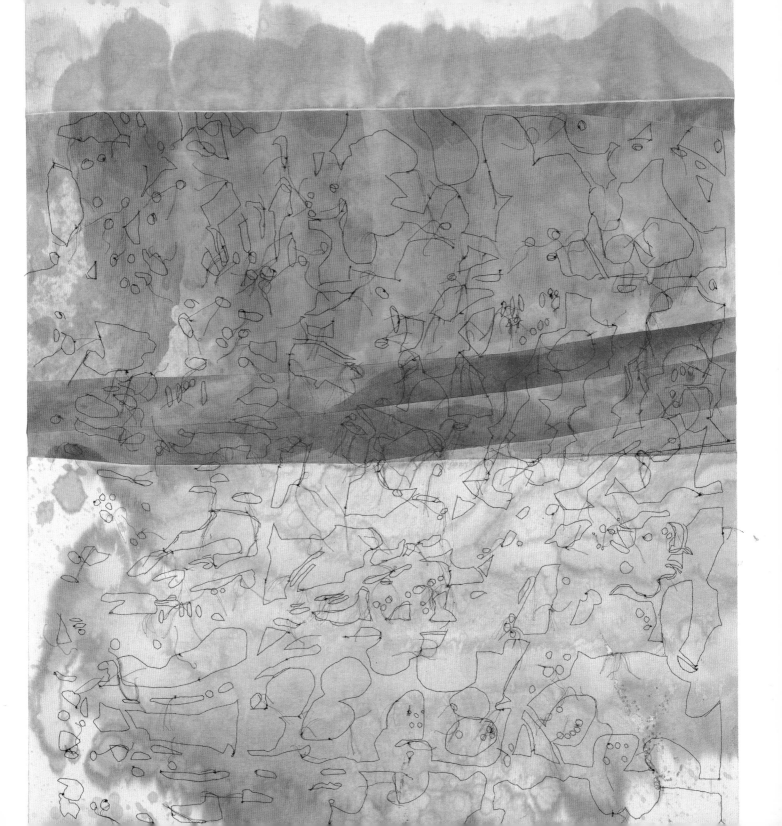

Berries
2003
acrylic paint, dye, thread
36 x 42in (91 x 107cm)

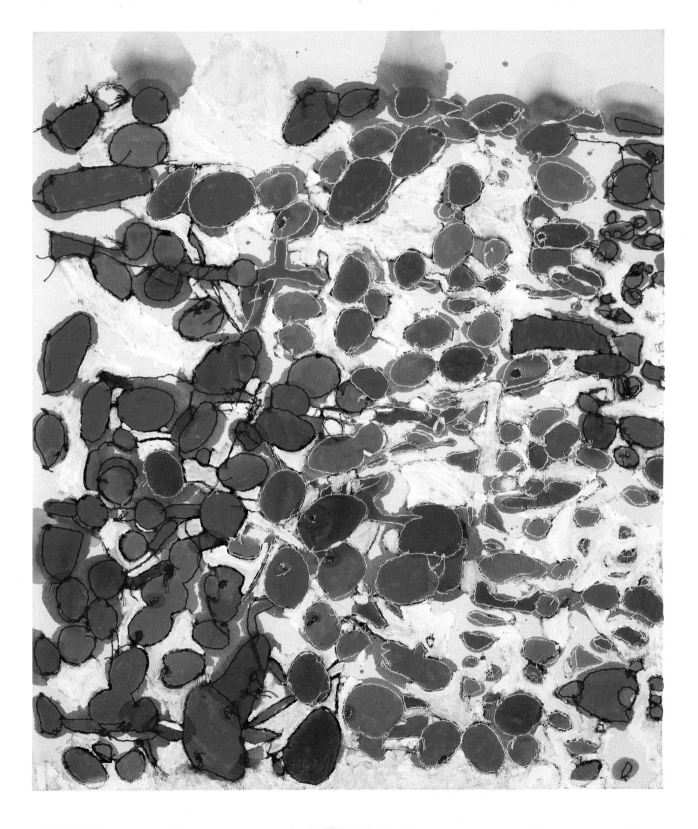

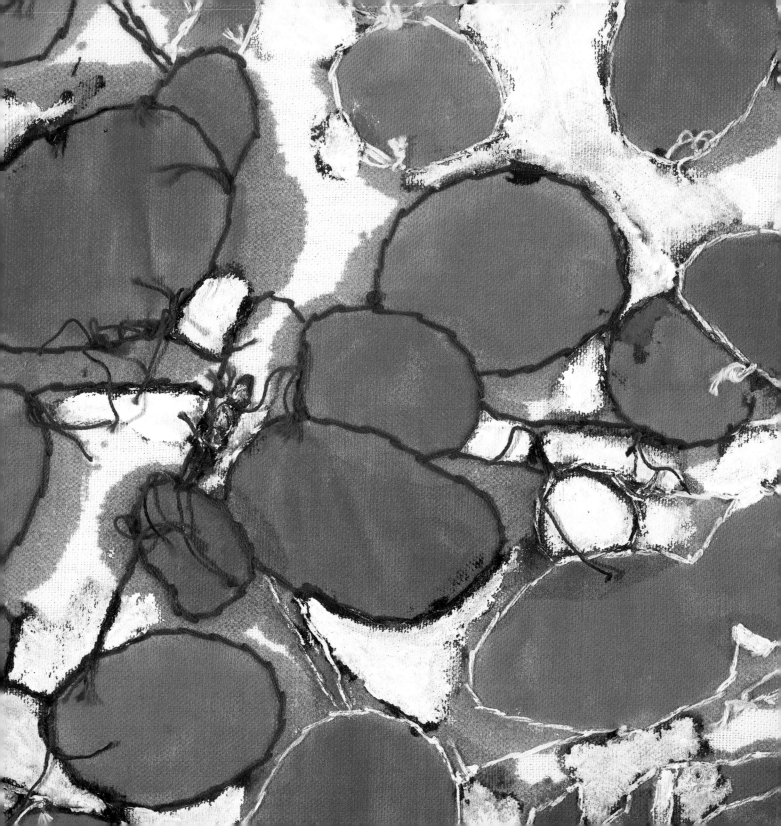

Color Plates

Berries (detail)
2003
acrylic paint, dye, thread

Candy Man
2003
acrylic paint, dye, thread,
pieced cotton
36 x 42in (91 x 107cm)

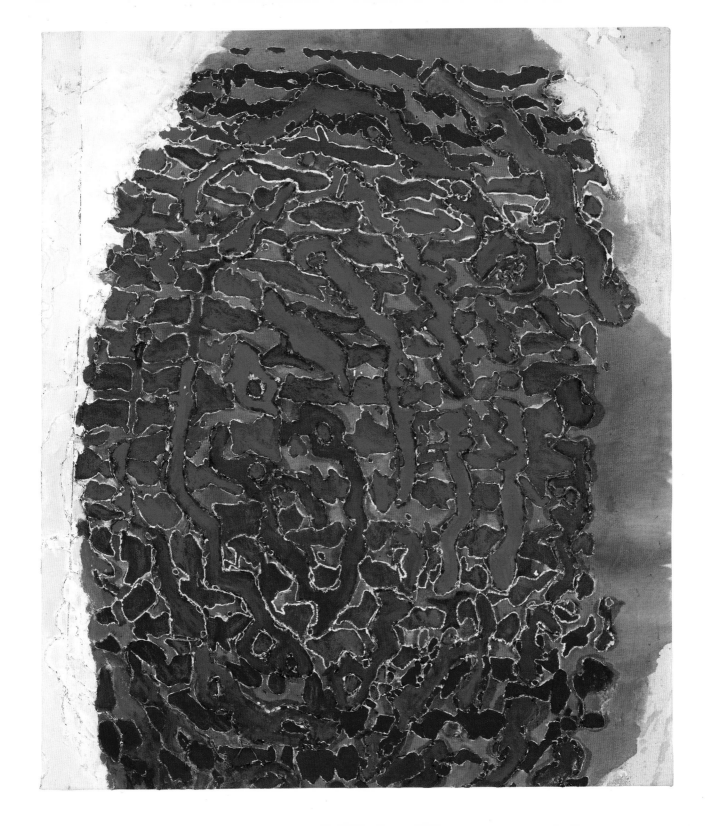

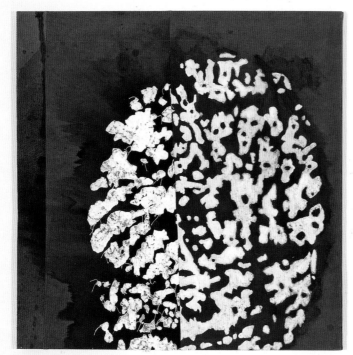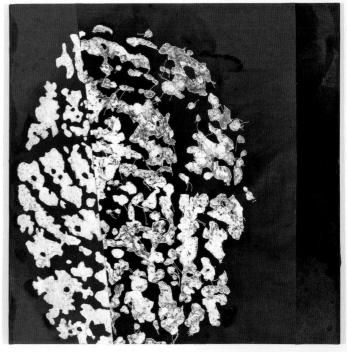

above:
Do Us Part
2003
diptych
acrylic paint, dye, thread,
pieced cotton
38 x 76in (96 x 193cm)

opposite:
Yes
2003
acrylic paint, dye, thread,
pieced cotton
38 x 38in (96 x 96cm)

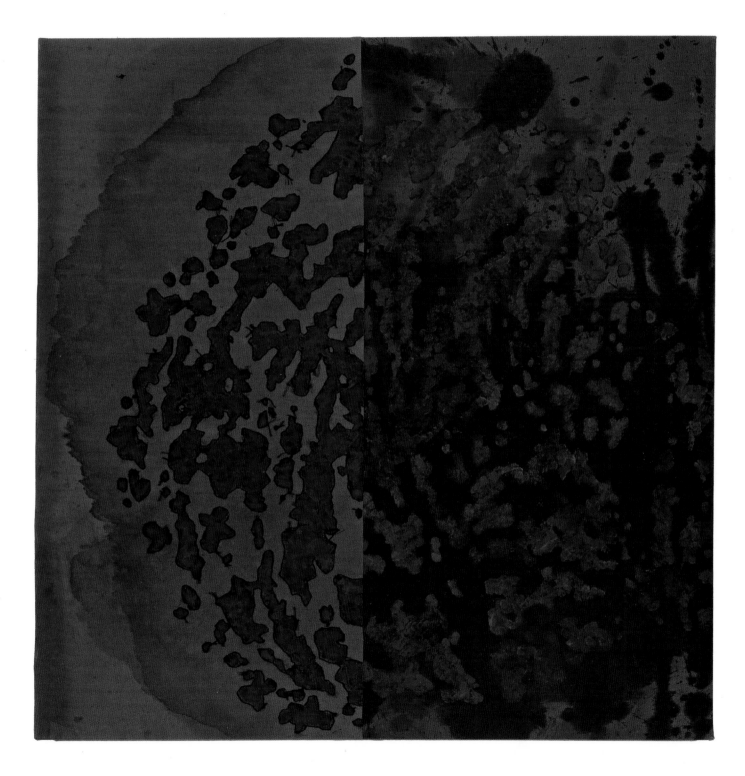

Sunset
2004
acrylic paint, dye, thread
30 x 30in (76 x 76cm)

page 38:
Spiral
2004
acrylic paint, dye
26 x 26in (66 x 66cm)

page 39:
Cyclone
2004
acrylic paint, dye, thread
28 x 29in (71 x 74cm)

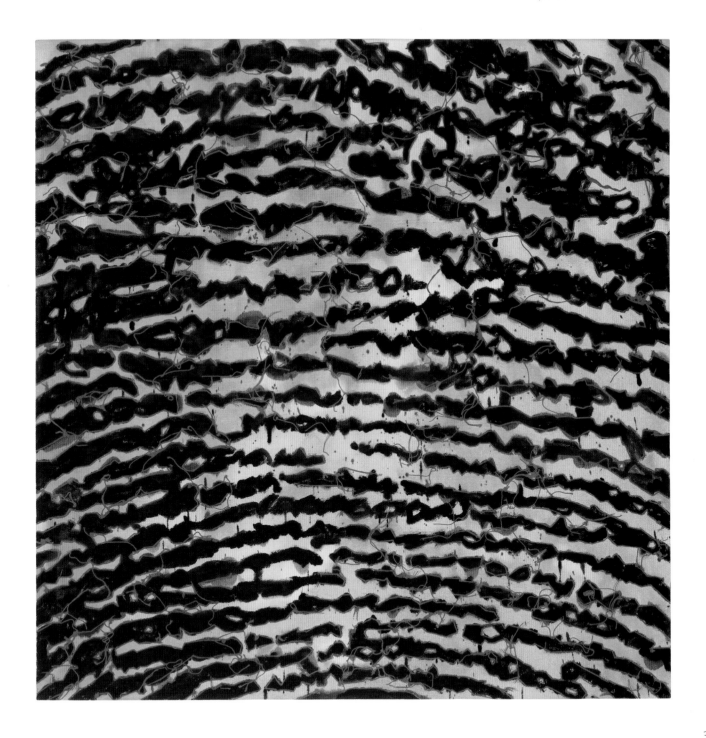

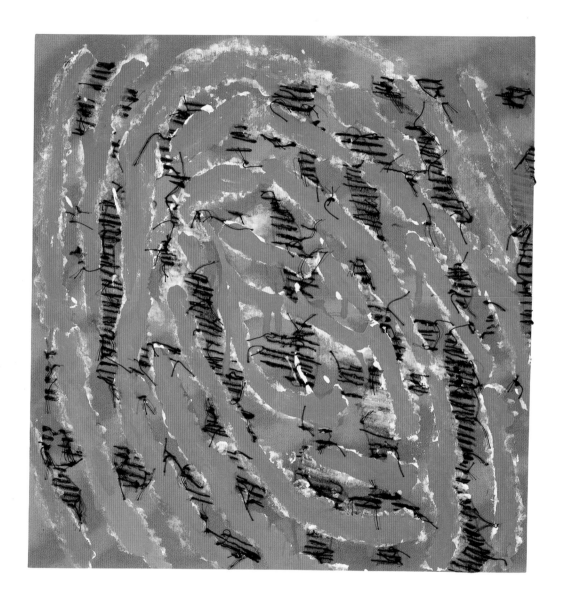

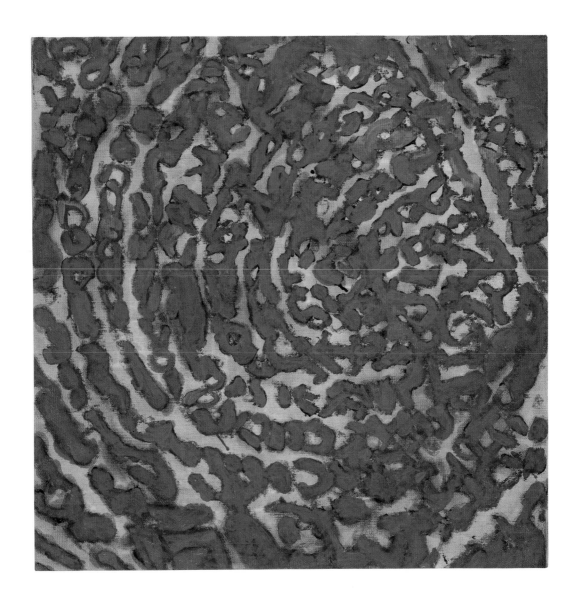

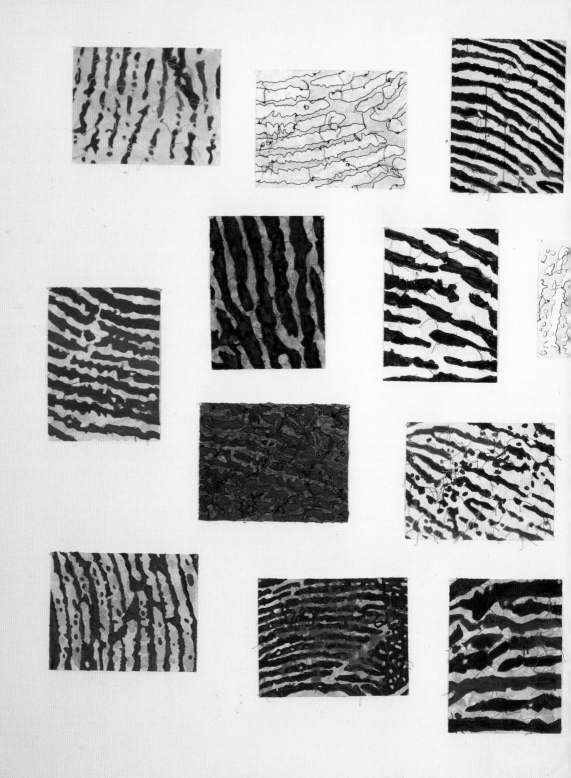

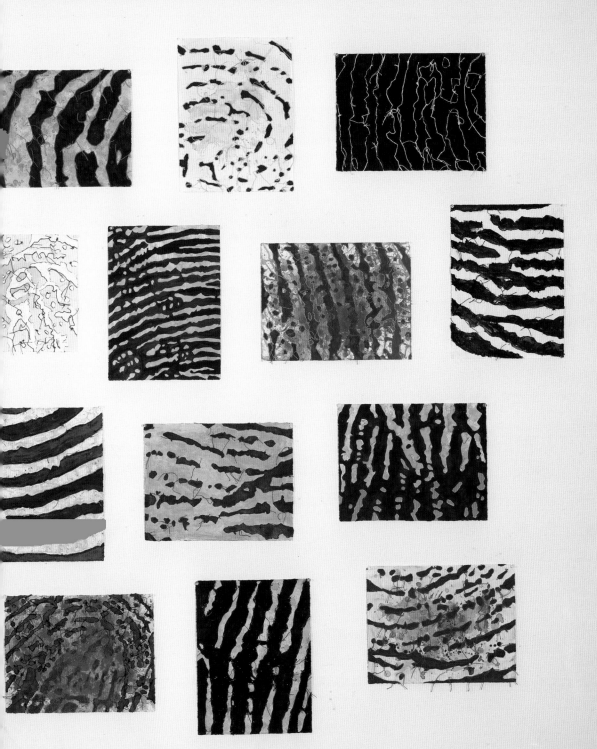

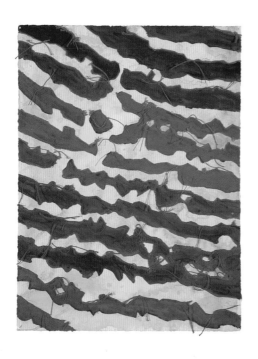
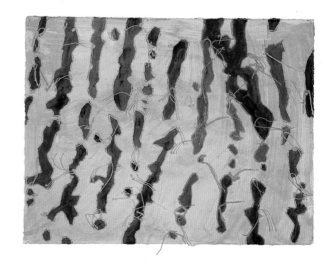

pages 40-43:
Only Me
2004
installation, 24 works on paper
acrylic paint, pearlescent paint,
thread on stonehenge paper
6 x 10ft (182 x 305cm)
each work 13 x 17in (33 x 43cm)

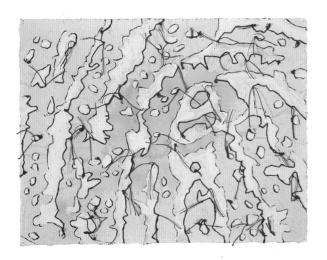

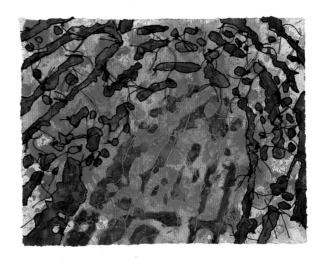

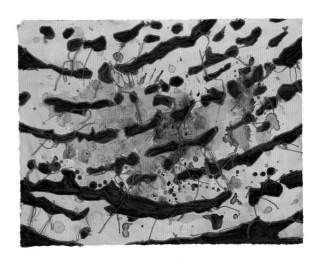

Biography

Born
1937 Chicago, Illinois

Education and Selected Awards
2003 Vermont Studio Center, VSC Award, residency fellowship
2002 Vermont Studio Center, Constance R. Dodge Foundation Award, residency fellowship
2001 Richard Florsheim Art Fund, Museum Purchase Award
 Pollock-Krasner Foundation
1996 Curator's Choice Award, *Artists Talk on Art*, New York NY
1991 Committee for the Visual Arts, Artists Space, New York NY
1985 Hereward Lester Cooke Foundation
1984 Ludwig Vogelstein Foundation
1974 M.F.A. Sculpture, San Francisco Art Institute, California
1959 B.F.A. Art Institute of Chicago, Illinois
1955-56 Rhode Island School of Design, Providence

Works in Public Collections
Boston Fidelity Investments
Israel Museum, Jerusalem
Museum of Arts & Design, New York NY

Selected Solo Exhibitions
2000 'Personal Markings II,' Art Resources Transfer, Inc., New York NY/Saint Peter's Church, New York NY, catalogue
1999 'Pepsodent Smiles,' installation, P.S. 122 Gallery, New York NY
 'Personal Markings,' Art Resources Transfer, Inc., New York NY
1997 'Two Left Feet,' *Site Specifics*, Carriage House Project, Islip Art Museum, East Islip NY, catalogue
1996 'Zig-Zag,' installation commission, *Between Fences*, National Building Museum, Washington DC
1992 'Window Screen Embroideries,' *In Memory*, AIDS Forum, Artists Space, New York NY
1991 'Holes,' Soho 20 Gallery Invitational Space, New York NY
1987 'Hands On,' installation, Sensory Evolution Gallery, New York NY
 'Paper Cut-Outs,' Public Image Gallery, New York NY

Selected Solo Exhibitions (continued)

1986 'State of the Art,' installation, Sensory Evolution Gallery, New York NY

1984 'Backfire,' installation, City University of New York, Graduate Center Mall, New York NY

1982 'Castle,' installation, City Hall Park, New York NY, Public Art Fund Project
'Con:cave and vex,' installation, Artemisia Gallery, Chicago IL

1980 '1999 Mirrors,' Special Project, P.S.1 Institute for Art and Urban Resources, Long Island City NY
'Mirror-Fence,' installation, Organization of Independent Artists, Wards Island NY, catalogue

1979 'City Gates,' installation, Battery Park City, New York NY, Lower Manhattan Cultural Council Project

1978 'The Men's Room,' Special Project, P.S.1 Institute for Art and Urban Resources, Long Island City NY

1977 'Wall Sculptures,' Newport Harbor Art Museum, Newport Beach CA

Selected Group Exhibitions

2005 'Scratching the Surface: Abstraction Now,' Delaware Center for the Contemporary Arts, Wilmington DE

2004 'Art on Paper,' Weatherspoon Art Museum, University of North Carolina at Greensboro, catalogue
'Trace Elements,' Albee, Miller, Temkin, Kristen Frederickson Contemporary Art, New York NY

2003 'Corporal Identity – Body Language,' 9th Triennial for Form and Content – USA and Germany:
museum für angewandte kunst, Frankfurt; Klingspor Museum, Offenbach, Germany;
Museum of Arts & Design, New York NY, catalogue
'Pins and Needles,' John Michael Kohler Arts Center, Sheboygan WI

2002 'Body Language,' Islip Art Museum, East Islip NY, catalogue
'Imprints, Punctures & Other Pointed Maneuverings,' Fine Arts Galleries, University of Rhode Island
at Kingston, brochure

2001 'Body Work,' The Work Space, New York NY

1999 'Common Threads,' The Gallery on the Hudson, Irvington NY

1998-91 'Making Waves,' installation, Socrates Sculpture Park, Queens NY, catalogue

1997 'Suture,' Rotunda Gallery, Brooklyn NY

1996 'Paper in Disguise,' Dieu Donné Papermill, New York NY

1994 'Susan Goldman, Laura Parnes, Merle Temkin', Trial BALLOON, New York, NY

1987 'Sundial,' *Tel Hai '87,* Contemporary Art Meeting, Tel Hai College, Upper Galilee, Israel, catalogue

1985 'Walker's Walk,' installation, Major Project Artist, Arts Festival of Atlanta, Georgia, catalogue

1982 'Indoors-Outdoors,' Friedman, Scott, Temkin, Foundations Gallery, New York NY
'New Sculpture: Icon and Environment,' *Views By Women Artists,* Women's Caucus for Art,
New York NY, catalogue

1981 'Merlin's Canopy,' installation, Major Project Artist, Artpark, Lewiston NY, catalogue
'Streetworks,' sculpture installation, Washington Project for the Arts, Washington DC

1976 'Eight Artists,' Art Rental Gallery, Los Angeles County Museum of Art, CA
1975 San Francisco Art Institute Faculty Show, CA
1960 2nd Biennial of American Painting and Sculpture, Detroit Institute of Art/ 155th Annual
 Exhibition American Painting and Sculpture, Pennsylvania Academy of Fine Arts
1959 62nd Annual Exhibition Artists of Chicago and Vicinity, Art Institute of Chicago IL

Artist's Publications
1981 Heresies #13 Earthkeeping/Earthshaking: Feminism & Ecology, vol.4 no.1, Nov., Editorial Collective
1980 'Hooker At Love' (Love Canal); 'Reflections;' '2 Rooms'

Selected Bibliography
2004 DiNoto, Andrea, 'Corporal Identity,' Review, *American Craft*, April/ May, pp.50-55, with illus.
 MacAdam, Barbara A., 'Corporal Identity-Body Language,' Reviews, *Art News*, April, p.112
2003 Auer, James, Cue, 'Sheboygan Center Draws Accolades on Own Terms,' *Milwaukee Journal Sentinel*,
 November 25, 2003, p.1E
2002 Van Siclen, Bill, 'Beneath Surface at URI,' Art, Live, *The Providence Journal*, February 21-24, p.12
2000 *Merle Temkin Personal Markings*, A.R.T. Press, New York, September, exhibition catalogue
1997 *City Arts*, 'Art With A View,' Socrates Sculpture Park, PBS Television, Channel 13, New York NY
1996 Koke, Kathleen, *Building Fences*, National Building Museum, Washington DC, CNN Television,
 October 26, artist interview
1992 *Grass Roots Art Energy*, Socrates Sculpture Park Exhibition 1991-92, catalogue
 Leimbach, Dulcie, 'Socrates Sculpture Park,' *The New York Times*, July 3
1987 Levine, Angela, 'New Spirit of Tel Hai,' *The Jerusalem Post*, Israel, September 23
 RISD/NY Newsletter, Winter, BIOS: 'Merle Temkin,' monograph, with illus.
 Bex, Flor, *Tel Hai '87*, Contemporary Art Meeting, Tel Hai College, Upper Galilee, Israel, catalogue
1986 Brenson, Michael, 'Merle Temkin,' Reviews, *The New York Times*, May 16, p.C25
1984 Glueck, Grace, 'Merle Temkin,' Reviews, *The New York Times*, July 6, p.C21
1981 Perreault, John, 'Parks Lot,' *The Soho Weekly News*, August 25, p.23
1979 Hatton, E. M., *The Tent Book*, chapter 5 Tent Art, pp. 144, 145, with 2 illus.,
 Houghton Mifflin Company, Boston MA

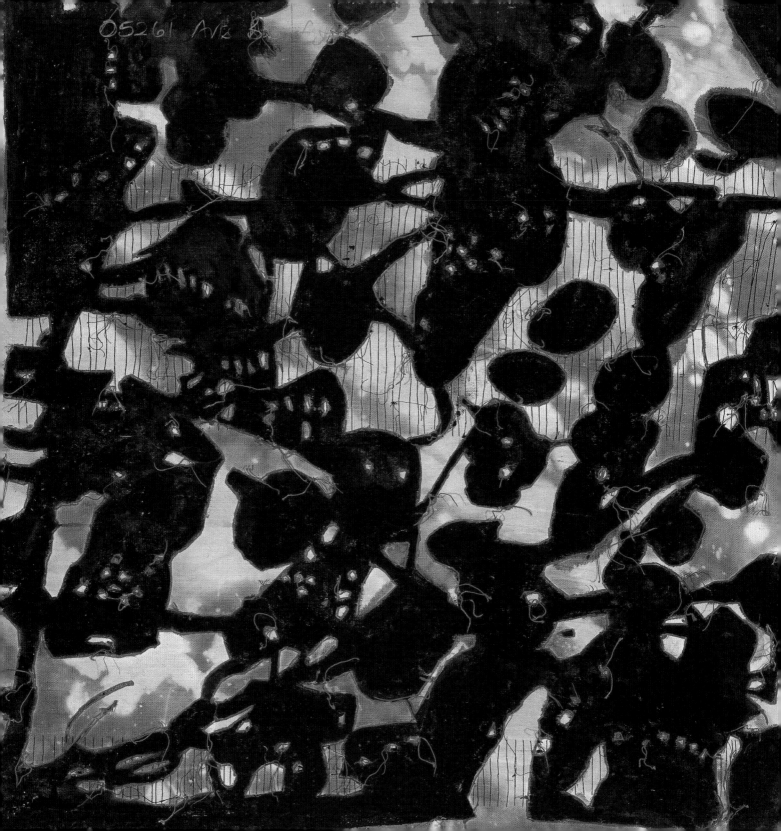